The Little Book of Litt͡le Gardens

Steve Wheen

Contents

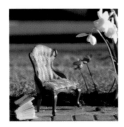
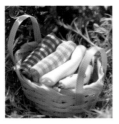
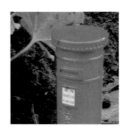
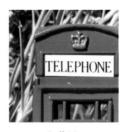
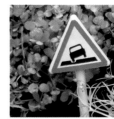

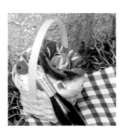
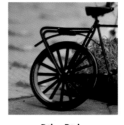
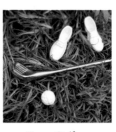

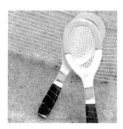

Tennis

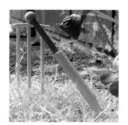

Cricket

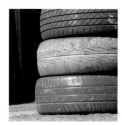

A and B Tyres

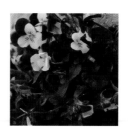

Wall Garden

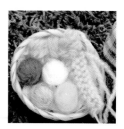

Stitch and Bitch

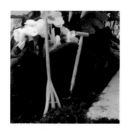

Bricking It

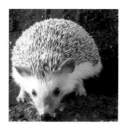

Hedgehog

Fashion Week

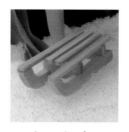

Snow Garden

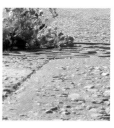

Man Whole

Gerbera

63

Colour

64

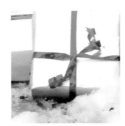

Christmas Garden

65

Night Garden

66

Canalside

68

Blainie Lanie

69

Pinkie Winkie

70

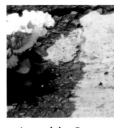

Around the Corner

71

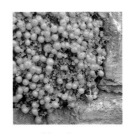

Very Berry

72

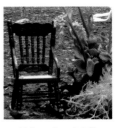

Take a Load Off

74

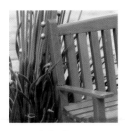
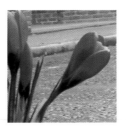
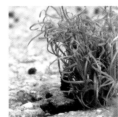

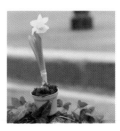
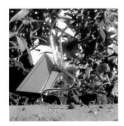
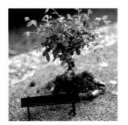

Foreword

There is a simple genius to Steve Wheen's pothole gardens. With nothing more than soil, flowering plants, and a few miniature props, he is able to stop his audience – aka general passers by – in their tracks. This is no mean feat when it comes to our busy city streets. As pedestrians, we're conditioned to keep our heads low, our eyes downcast and our minds elsewhere as we navigate our urban world.

We've always got some place to go and somewhere else to be. And, while we're getting to wherever it is we are already five minutes late for, the experience is rarely pleasant. We're bombarded with advertising promising us a better life or playing on our fears. We're assaulted by the sight and stench of last night's vomit and pavements streaked with urine and whatever has been left behind by sly dog owners too lazy to pick up after their animals. We're tripped-up, elbowed and jostled by the crowds. We stick headphones in our ears, hoping that our own personal soundtrack will take us any place far away from where we are right at that moment.

If someone does manage to distract us while we rush from A to B, it's often because they want something. Spare change, directions to Big Ben or a brief moment to press a leaflet into our hands in the hope that they might save our souls, teach us salsa or offer a two-for-one at the greasy pizza place down the next lane. It's no wonder that suspicion is our default position for such encounters. We have no patience, we resent the disruption and our collective benevolence is rare.

So, what is it about Steve's pothole gardens that breaks us out of this well-trodden rut and touches us so deeply? Is it that he's actually spent some time in the same spot on the street? Is it the narrative of his gardens? Or perhaps it's the empty chairs and tables that our imagination lets us believe could've once been home to the modern-day *Borrowers* or the cast of *Honey, I Shrunk the Kids*? Perhaps we're merely in awe of his idea – and the fact that he's taken the time to implement it. Ultimately, however, all the questions raised by these little gardens are subjective and personal.

I find it interesting that Steve is so often compared to infamous street artist Banksy. On the surface, it's easy to understand why. Both operate in predominantly urban environments. Both use public infrastructure as their canvases. And the authorities sanction neither Banksy's art nor Steve's gardens. It's the motivation behind the creations, however, where the two differ.

Bansky's work comes from a place of anger and frustration. His pieces are, more often than not, political protests, illustrating silly ironies, contradictions and hypocrisies. His identity is purposefully guarded, he's staunchly anti-capitalist and he risks arrest each time he grabs for his spraycan. Steve, on the other hand, is not trying to make a political statement, though most people viewing his gardens assume that he's an ecowarrior or that he's demonstrating in silence (and beauty) against the local council and their neglect of road maintenance. But, despite the fact that he refers to himself as a guerrilla gardener, his reasons are much simpler.

Born in Australia into an outdoorsy, gardening mad family, growing up Steve loved nothing more than to potter about in the backyard. It also helped that a love of horticulture was in his blood – Steve's grandfather was the first person to cultivate a daffodil with a red trumpet. So, it's easy to understand why leaving this kind of life to live in London could come as quite a shock.

Of course, London is an amazing city, but space is most definitely at a premium and you spend much more time indoors than out. Most people put up with pokey homes with little or no garden or balcony, but not Steve. Instead of allowing himself to be confined by the four walls of his flat, he decided to do something about it. And thus armed with his knowledge and love of plants and the ubiquitous supply of potholes and other cracks in the pavement around his Hackney home, The Pothole Gardener was born.

With a new way of looking at poorly maintained infrastructure, every dent, folded and mottled slab of bitumen he could find in East London has had a make over, temporary or otherwise.

Instead of rueing a missing paving stone or tut-tutting at eroded nooks and crannies in the pavement, Steve thought of new and ever more elaborate ways of fashioning his small-scale worlds. And, what started as a weekend project has now become something of a phenomenon, attracting local and international media attention and a legion of fans, including me.

For Steve, it's the reaction of the people who encounter his gardens that has been the most surprising. On the street, people have been known to take pictures, steal his flowers and stop and stare . His little gardens have attracted all sorts of animals, including inquisitive pigeons, skittish squirrels and their fair share of dogs. People have shaken their heads in wonder, smiled wryly and run over his gardens with their cars. Some have promised to water his flowers and protect his plants. Online, his videos and blog posts have been shared countless times, from fellow bloggers the world over and local publications to media juggernauts such as The Independent, CNN and Oprah.

The reasons for his success are obvious. Steve's little gardens are beautiful, ephemeral and whimsical. I've been privileged to go pothole gardening with him a couple of times, and I'm always amazed at how his creations make me and the others who gather to watch us so purely happy. It's because he's giving us something innocent and unsullied. And it's because he wants nothing back from us in return. His simple creations are a reminder of the good in people and they make us present and appreciative of our world. And therein lies his genius.

Kate McAuley
April 2012

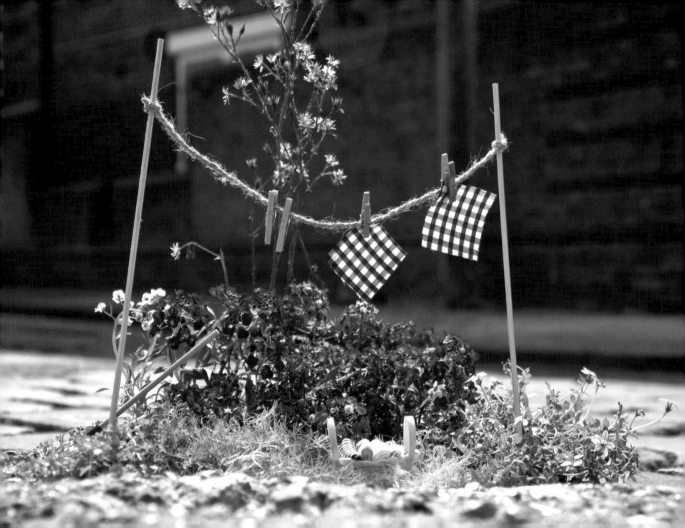

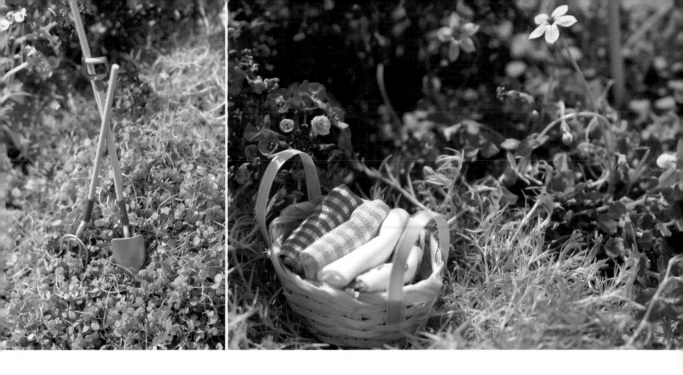

Putting out the Clothes

There's nothing quite like clothes dried on the line, right? Pedley Street got a little line of its own as we hung out some mini tea-towels to dry.

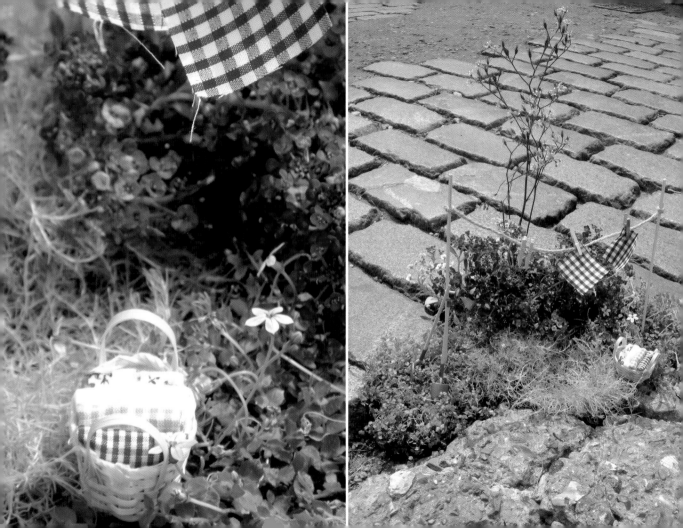

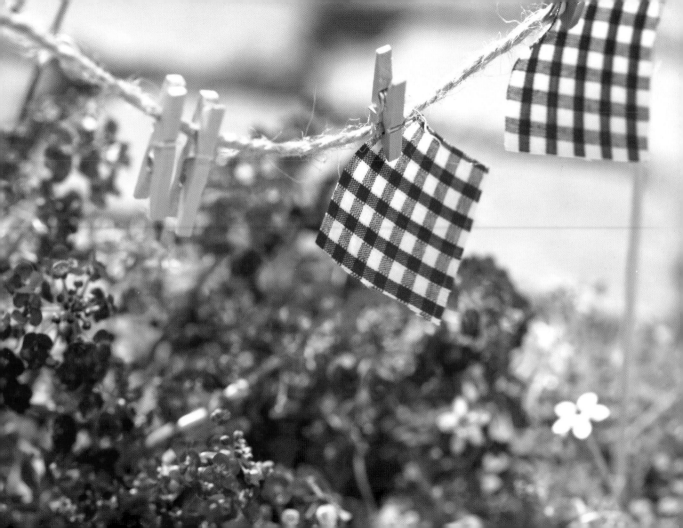

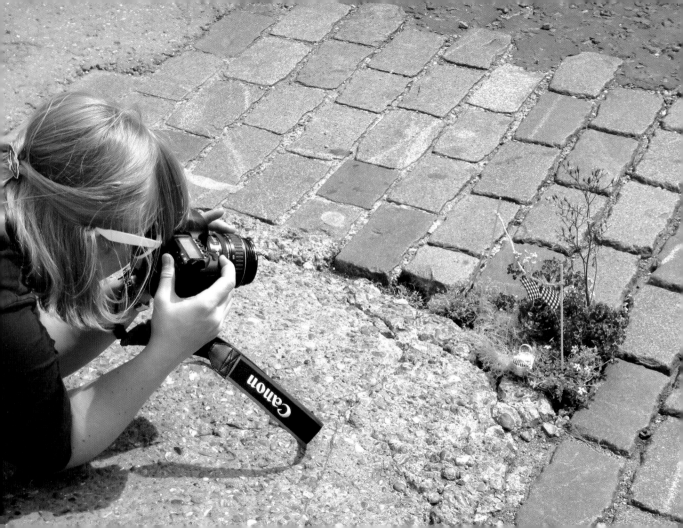

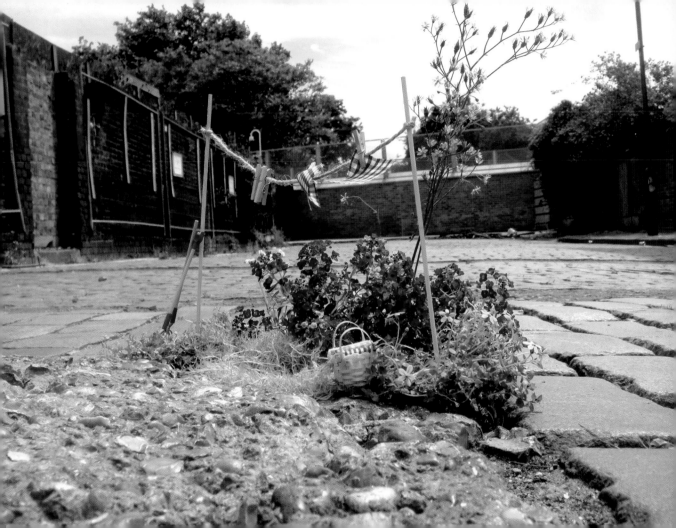

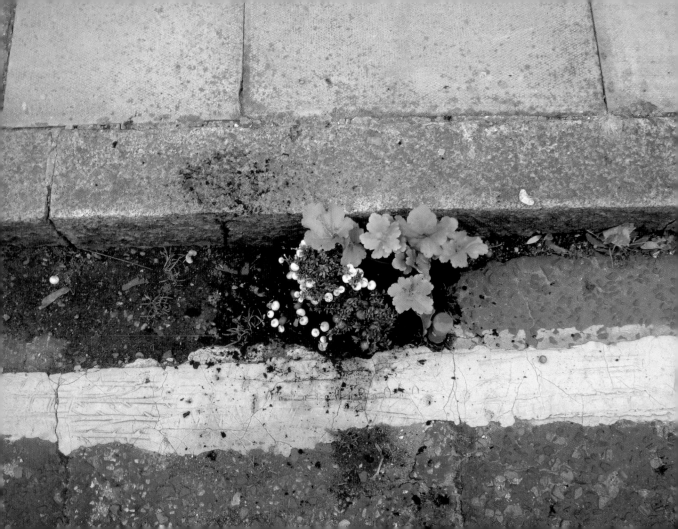

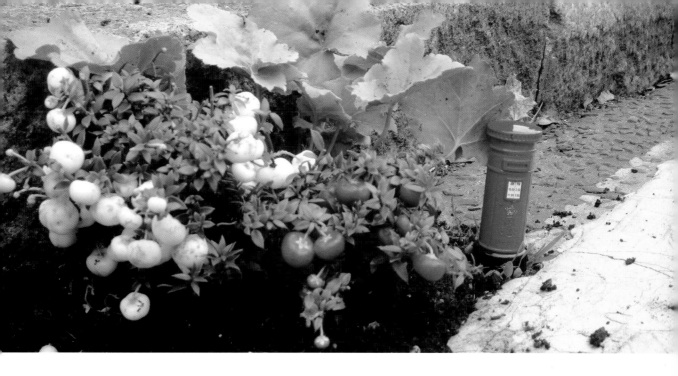

Going Postal

Receiving a letter is so much more exciting than an email.
This garden was created behind Columbia Road Flower
Markets in an unloved gutter. Send someone a letter.
It may be a little one if you use this postbox, but it's the
thought that counts.

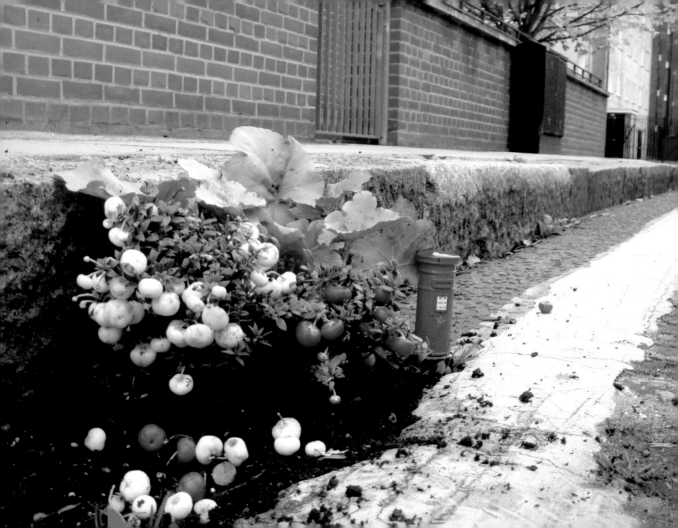

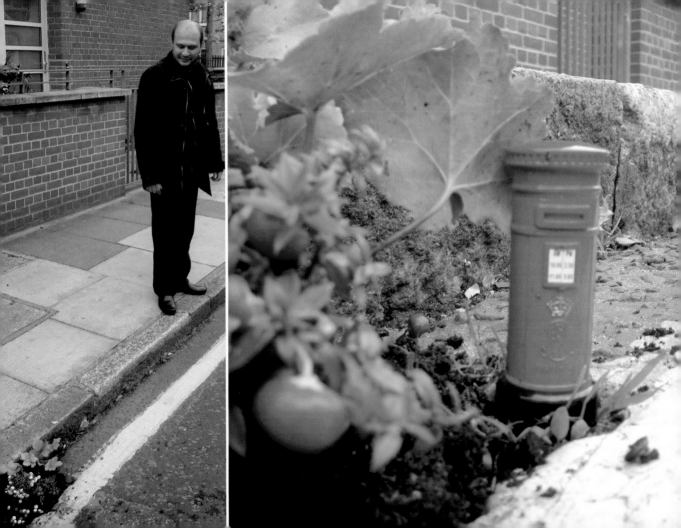

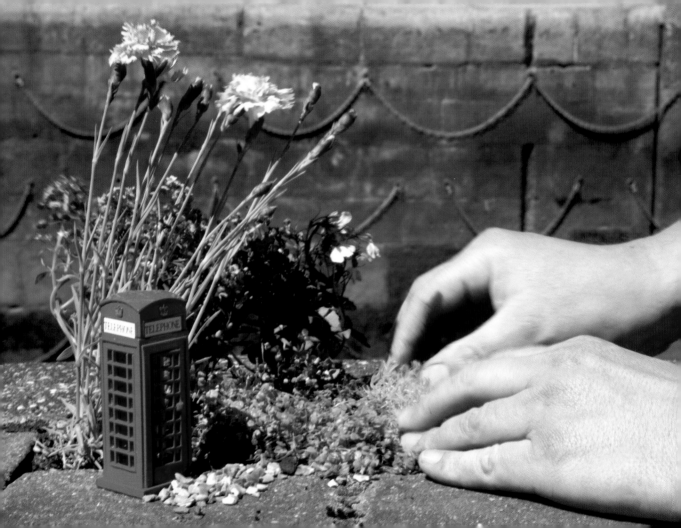

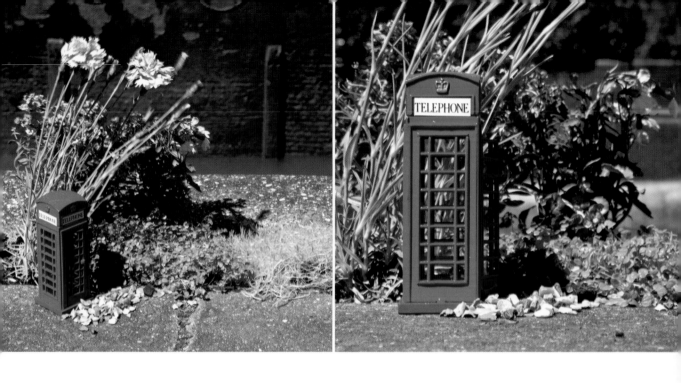

Call Me

One of London's favourite icons in the shadow of another.
The London Phone Box is painted red so they're easy to
spot – lucky as this little one is easy to miss.

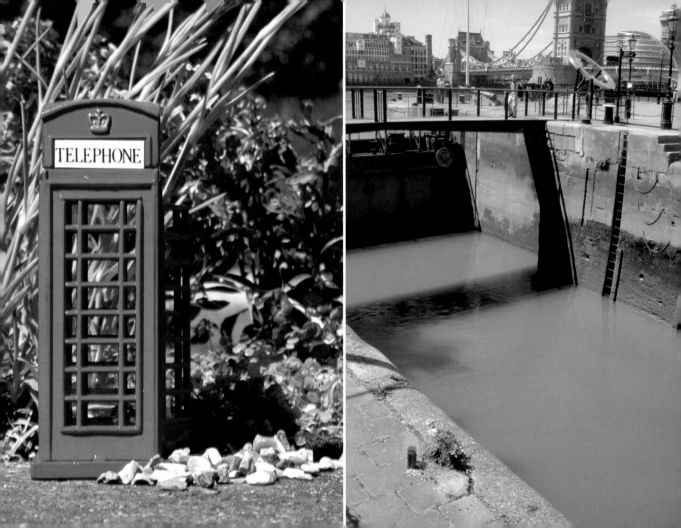

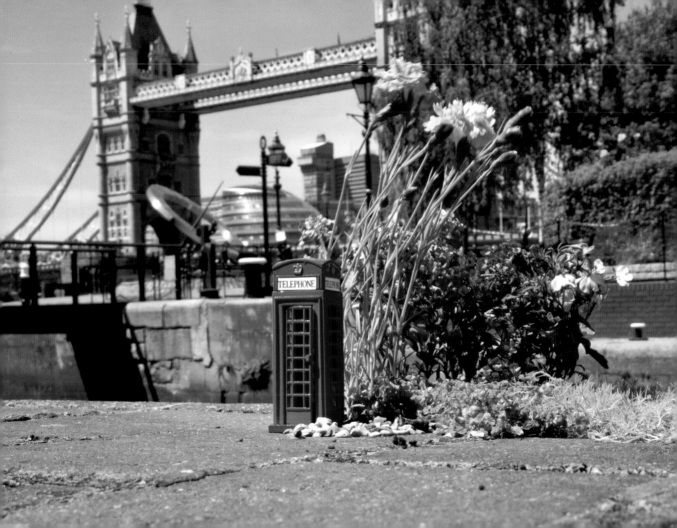

Confused

A road, on a road. All this garden needs is a little car. But beware of the potholes.

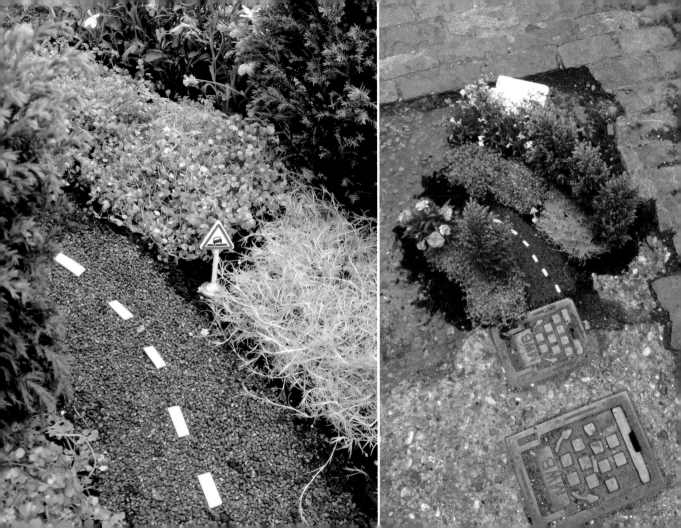

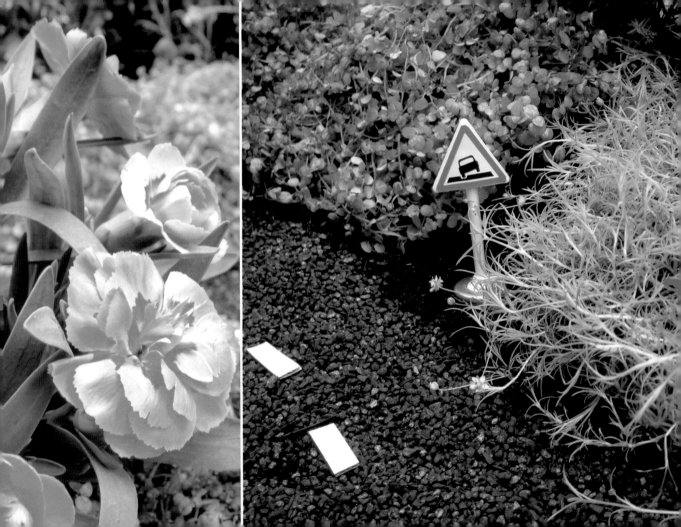

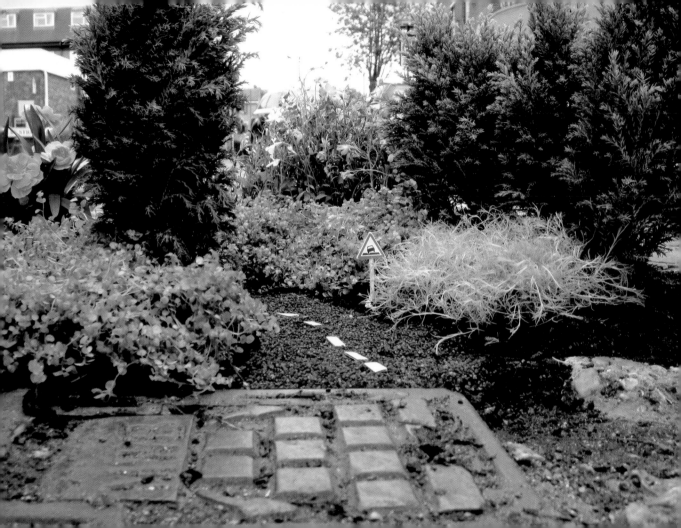

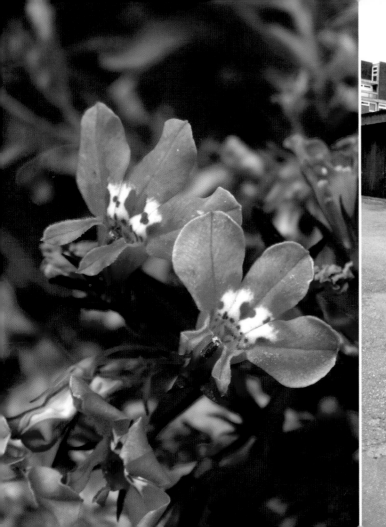

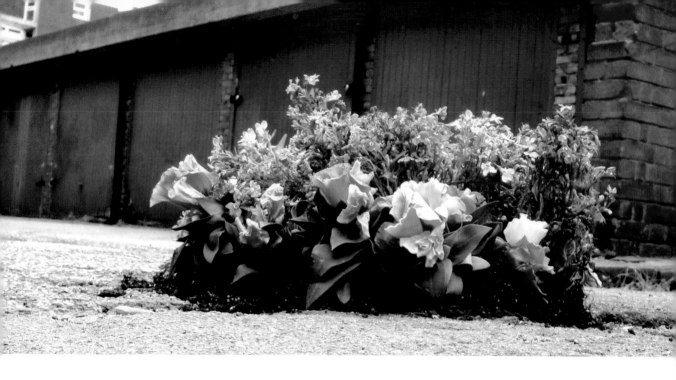

Love London

London needed some love after the 2011 riots.
I gave it in the form of pink and purple blooms
in a pothole in Chart Street, Shoreditch.

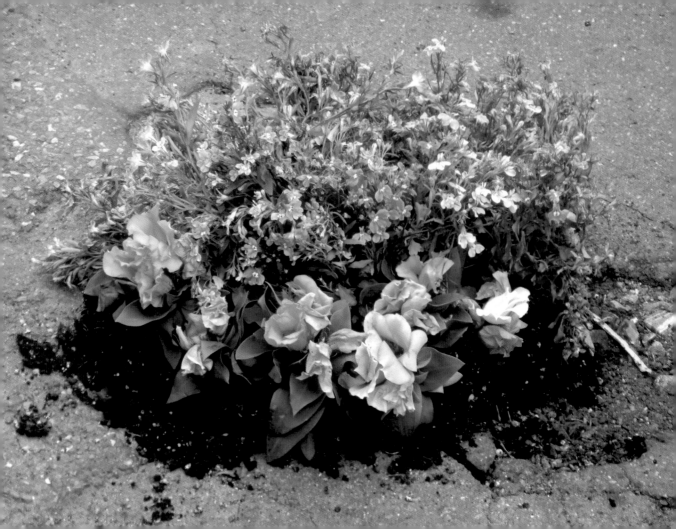

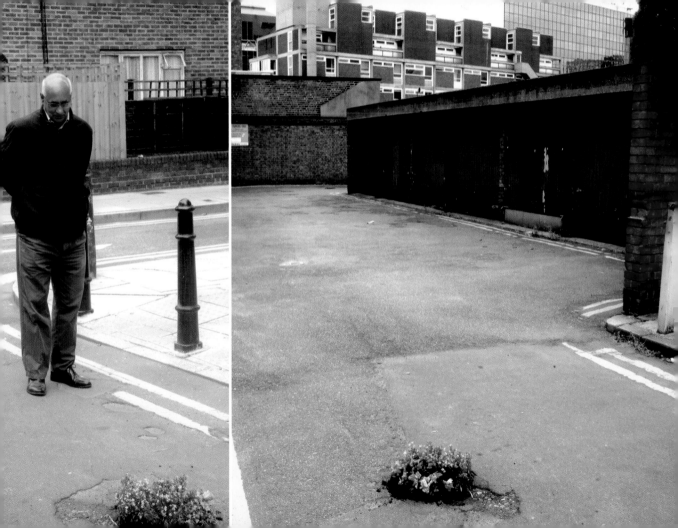

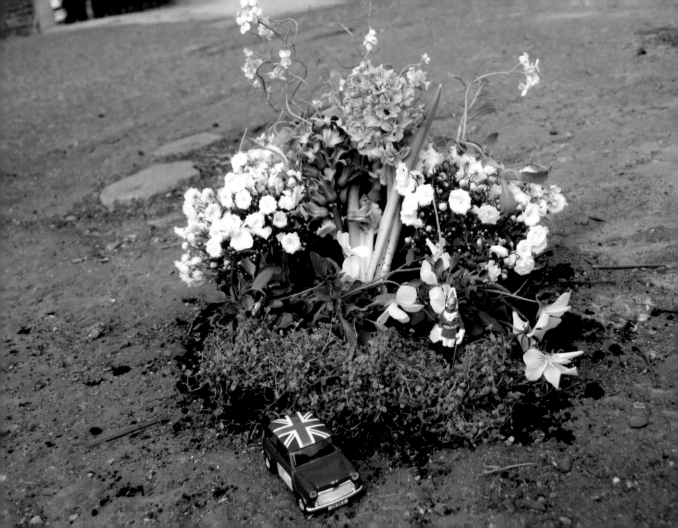

Royal Garden

A little garden celebrating a big day. One of the first gardens I created in East London – in fact I ventured to the Queen's postcode. Congratulations Will and Kate.

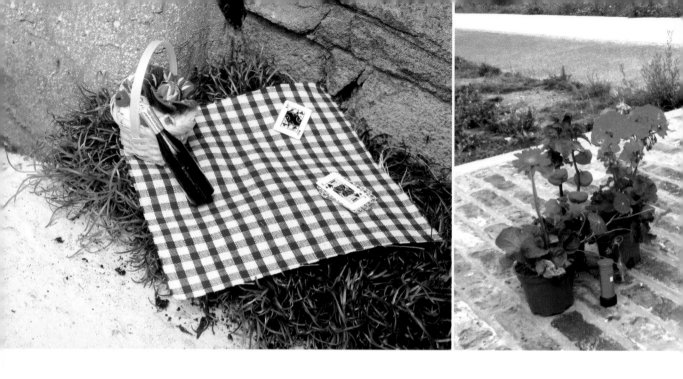

Time Out

Next to the new Westfield Stratford, here's a wee garden
for tired shoppers to take some time out.

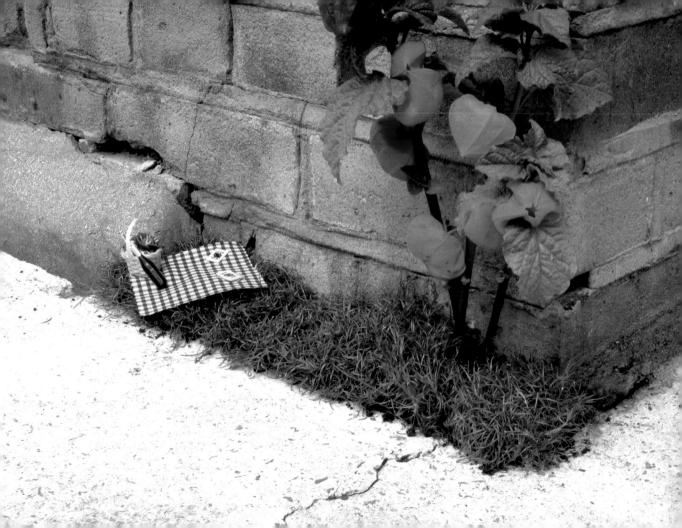

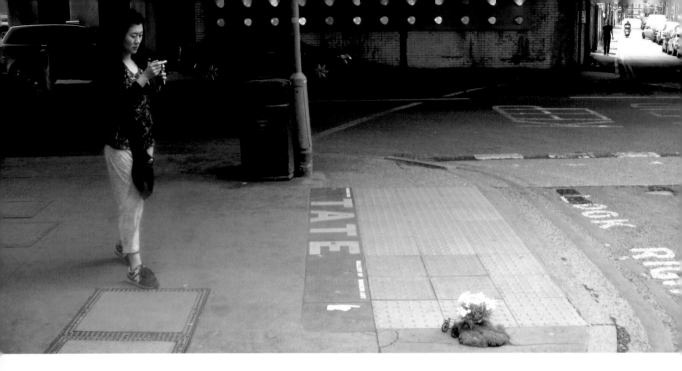

Bike Ride

This garden was created just south of the river, at Borough Market, in memory of all my bikes that have been stolen. I hope they're happy and being treated well.

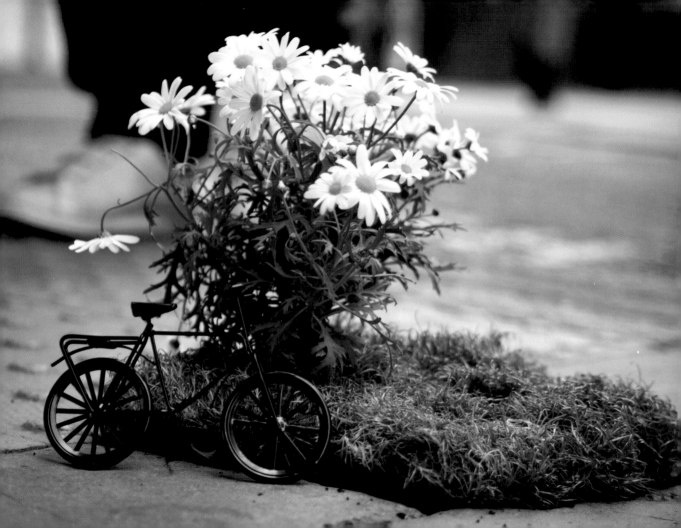

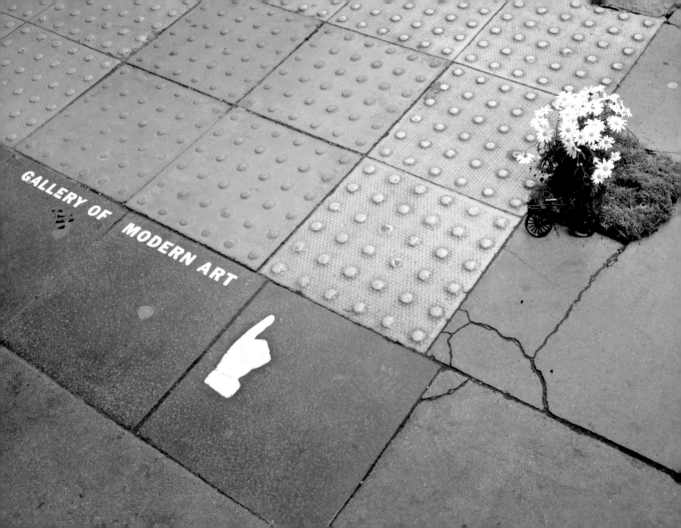

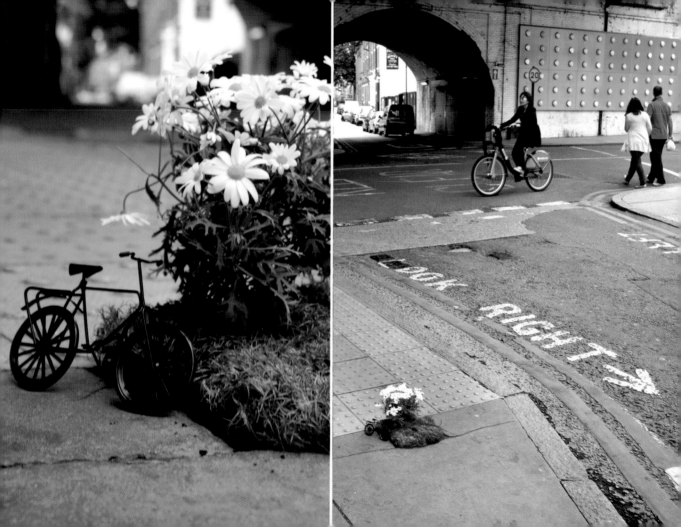

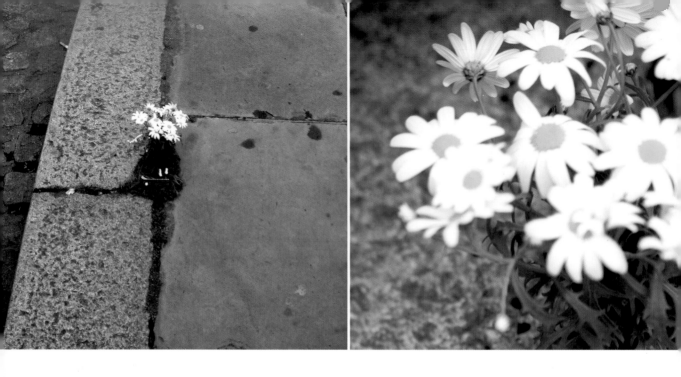

Gone Golfing

In the shadow of St Paul's Cathedral, this little golfer has taken a break from his game to pop in to speak to the man upstairs.

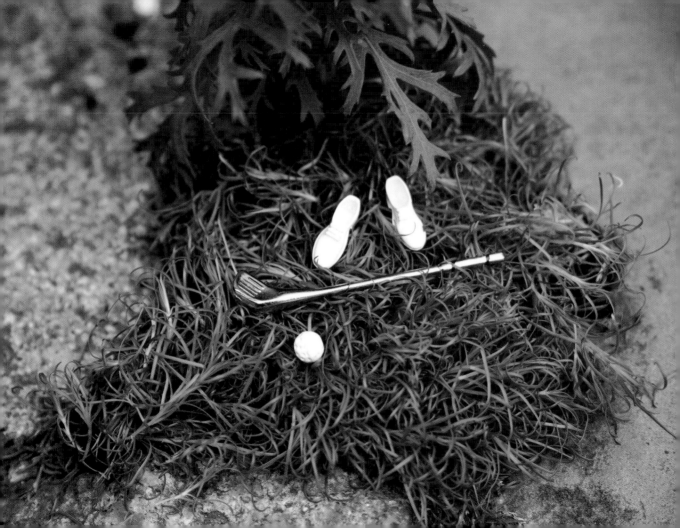

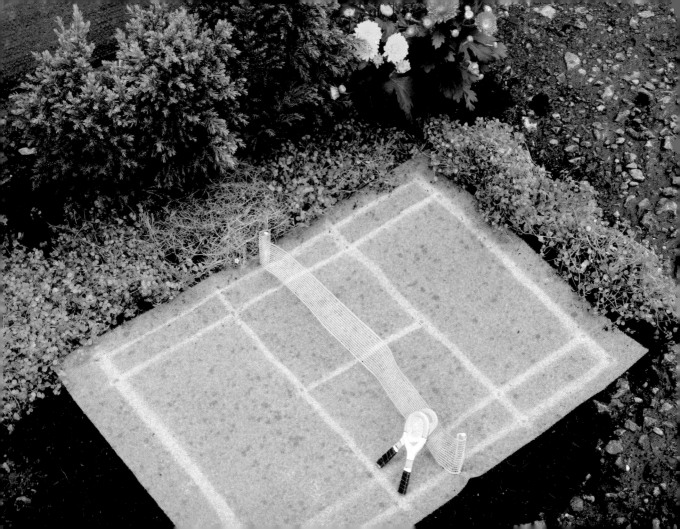

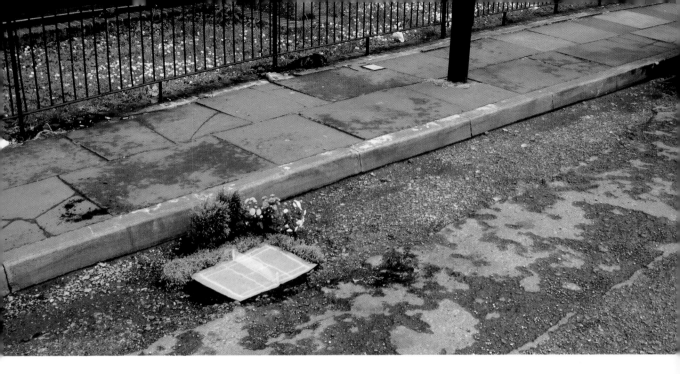

Tennis

Celebrating Wimbeldon, one of London's greatest sporting events. The only thing missing from this garden in Selby Street is champagne and strawberries.

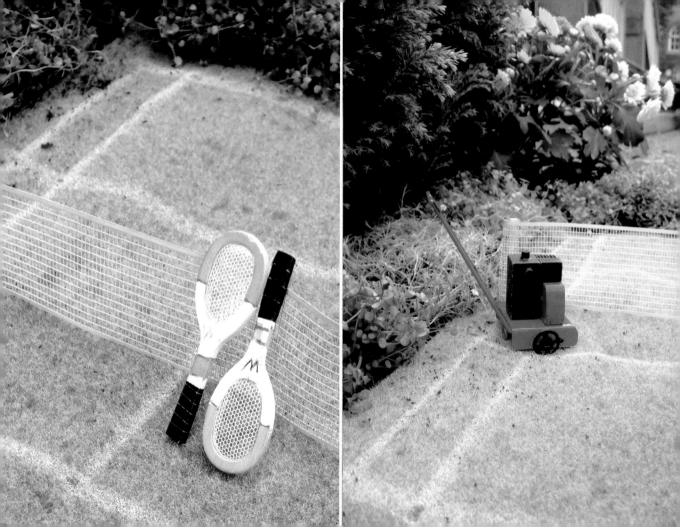

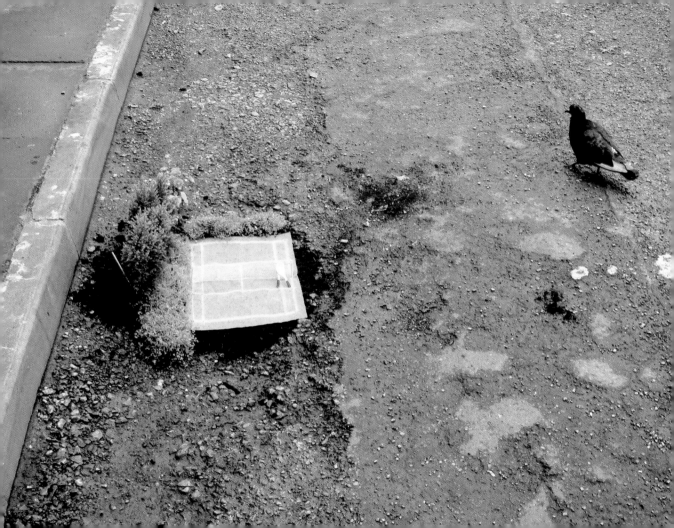

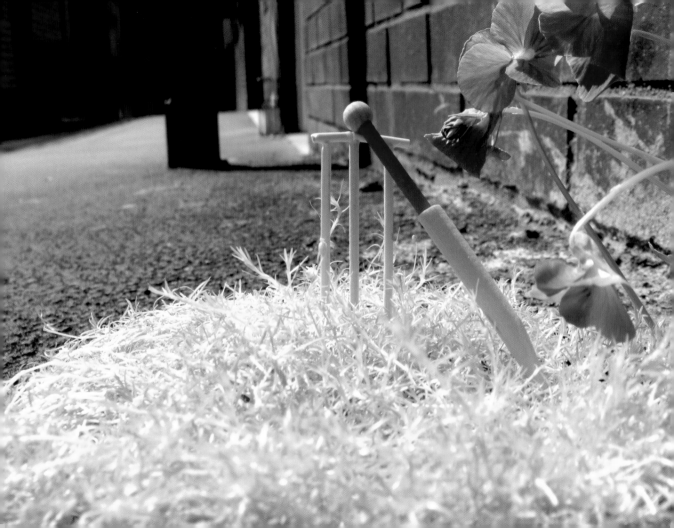

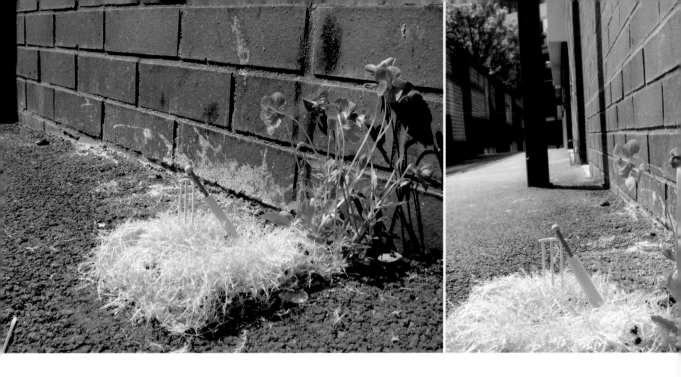

Cricket

In support of the Australian cricket team, Old Montage Street, Whitechapel, got this miniature cricket pitch, complete with a pansy, to give them a little lift. Sadly, it didn't work.

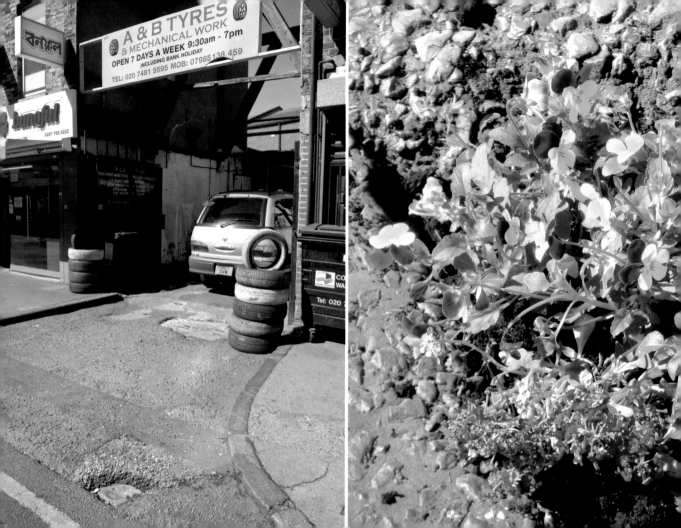

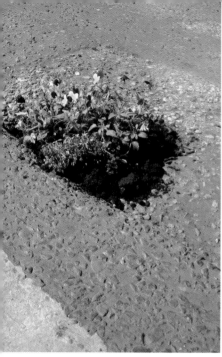
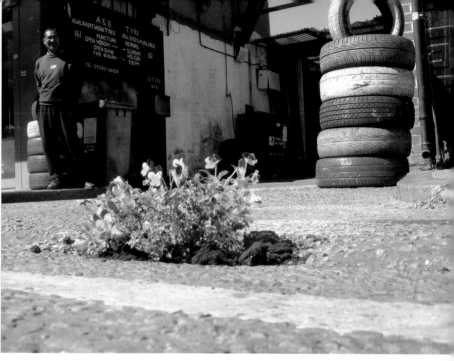

A and B Tyres

A little garden with all colours from A to Z in Cannon Road. The drivers in Cannon Road drive like cannon balls and it didn't last long.

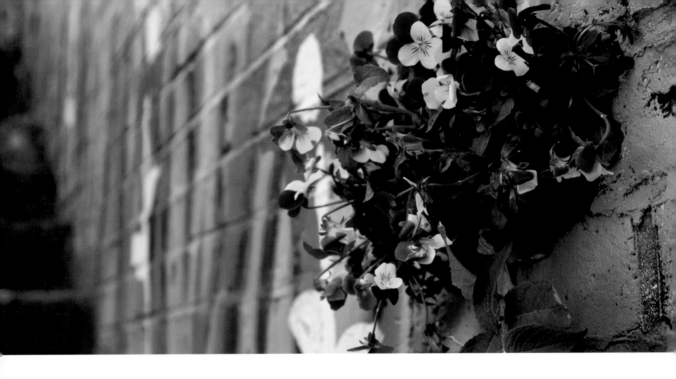

Wall Garden

This hidden gem of graffiti in London lives on the walls of this little known overpass next to Hare Marsh. Pansies in the wall, wall art?

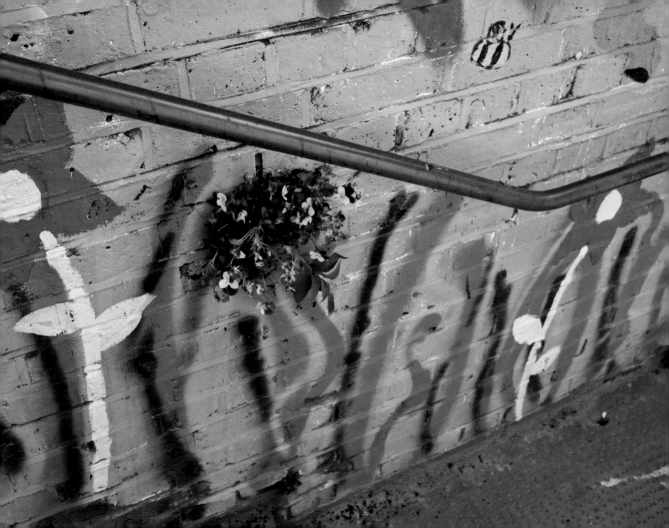

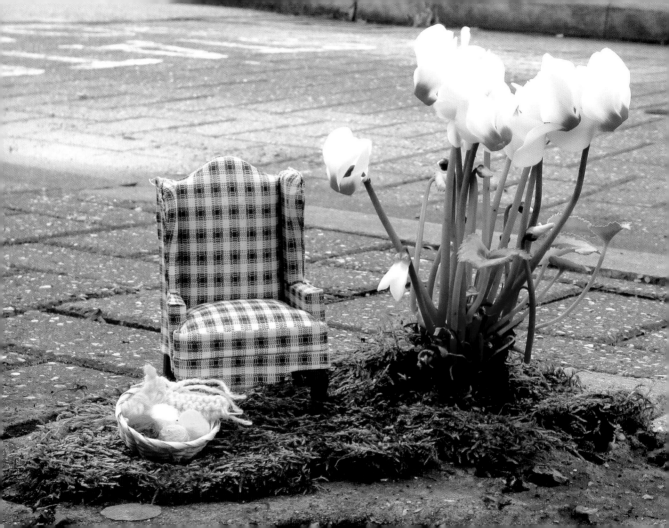

Stitch and Bitch

Things made with love are always better, be it a sweater or a miniature garden. This garden was made with love on Moss Lane.

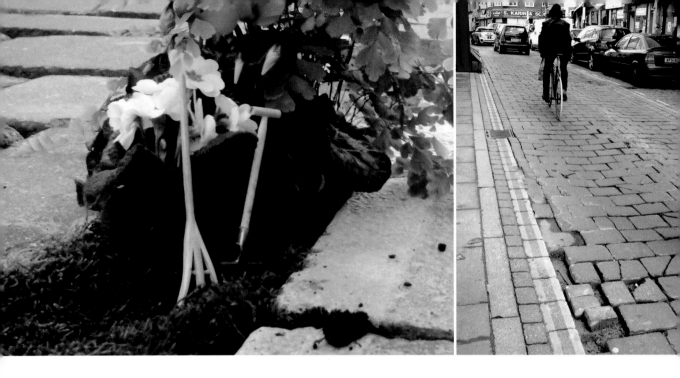

Bricking It

Brick Lane, famous for its curries, was short a few bricks.
To compensate we filled this gap with some poppydoms.

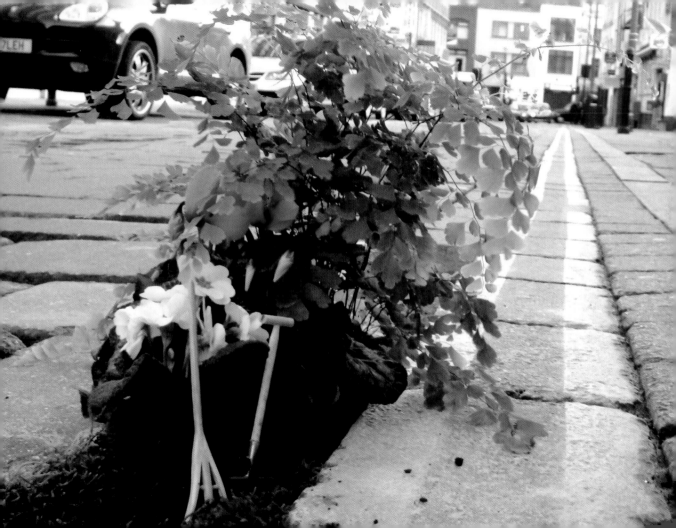

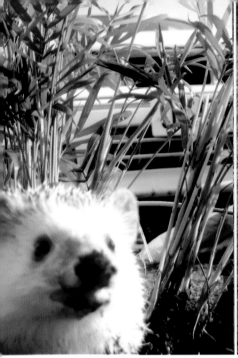
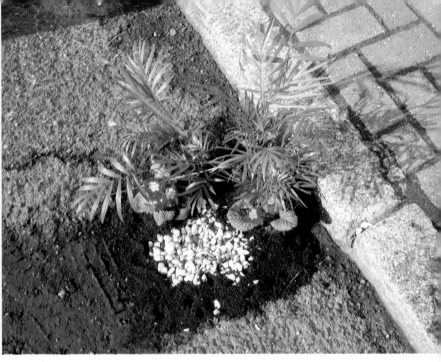

Hedgehog

In Midmay Grove, Dalston, this small garden got a very sweet little visitor who seemed to enjoy his new home next to the road.

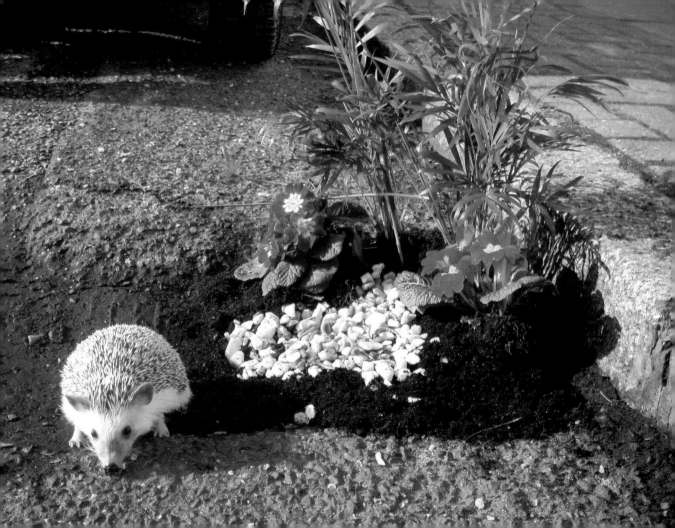

Fashion Week

London loves fashion week. Glasgow Terrace had a runway show of its own with these floral delights.

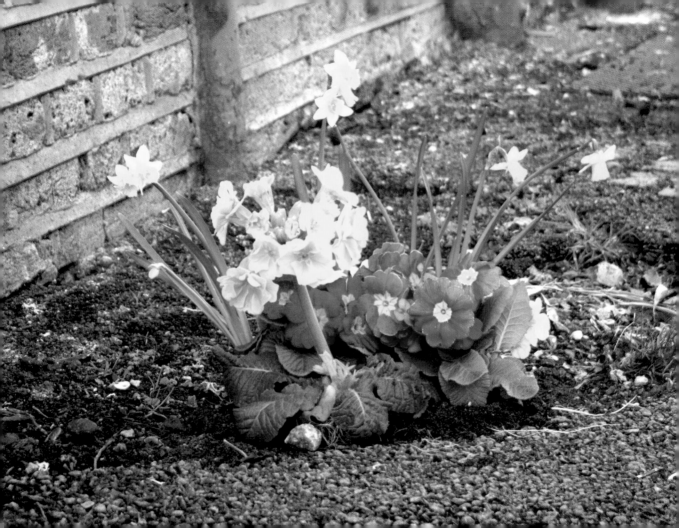

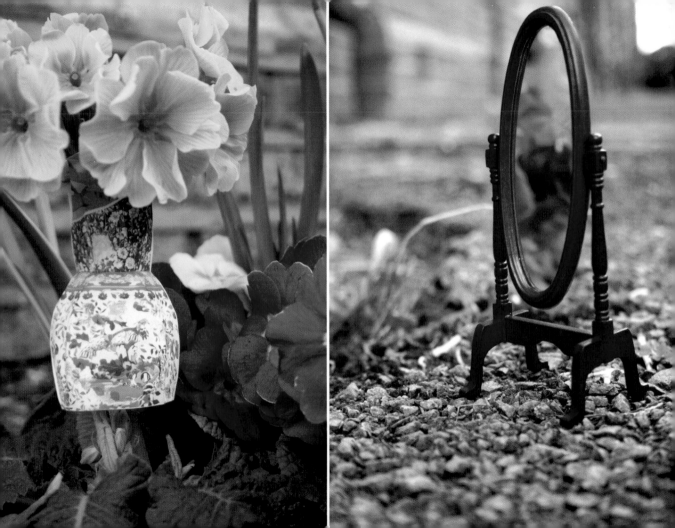

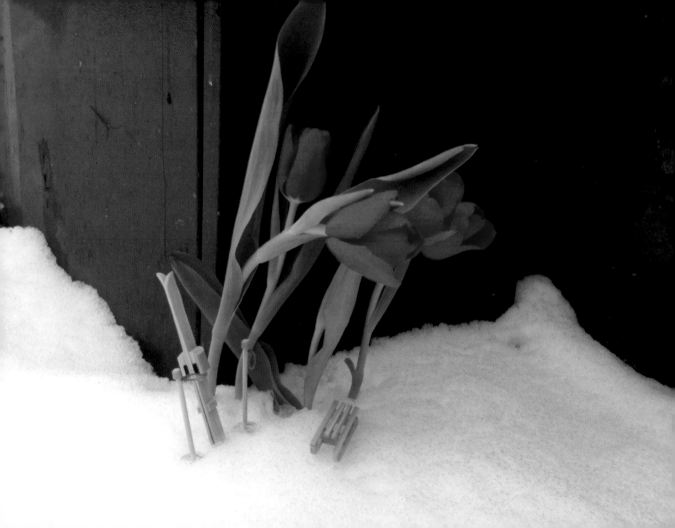

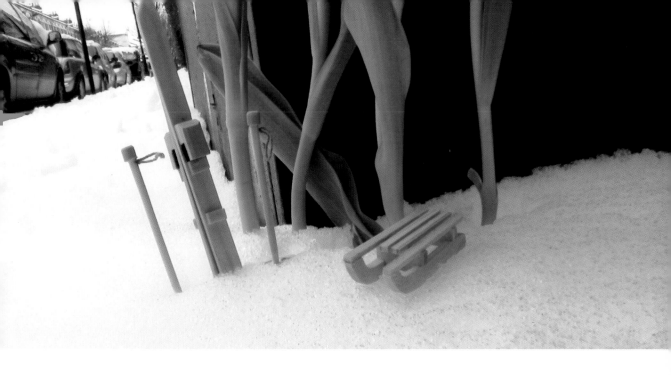

Snow Garden

London under snow is always special. Celebrating the white stuff, these four tulips in Finsbury Park were a treat for passers by.

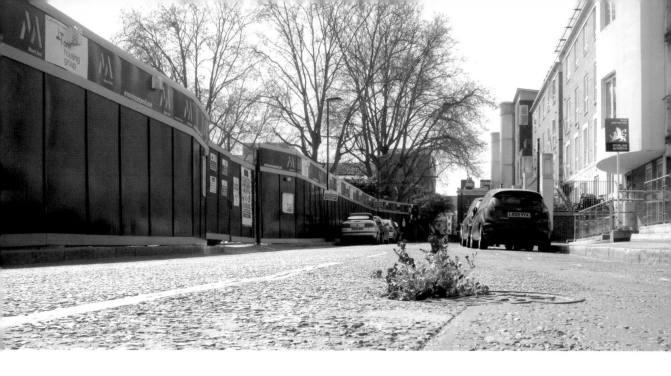

Man Whole

A manhole in North London provided the perfect home for a little garden that only lasted a little time.

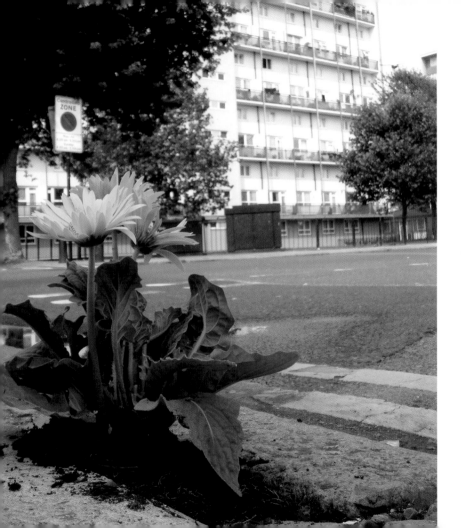

Gerbera

This little Gerbera just off Bethnal Green Road is right near a Banksy piece. I've been called the Banksy of Horticulture. I prefer the Banksia of Horticulture.

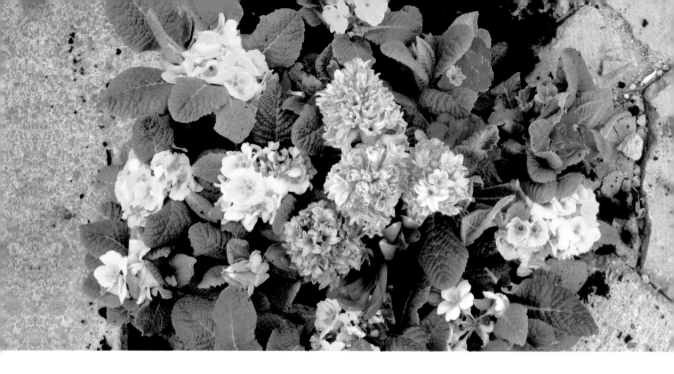

Colour

A little bit of colour can go a long way. I guess the fashionistas might call this colour blocking!

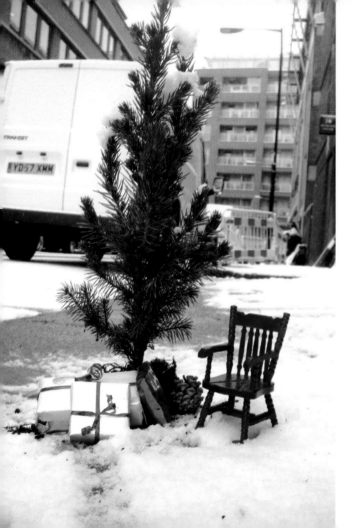

Christmas Garden

Christmas arrived early in Mulberry Street.
Little presents for some little people.

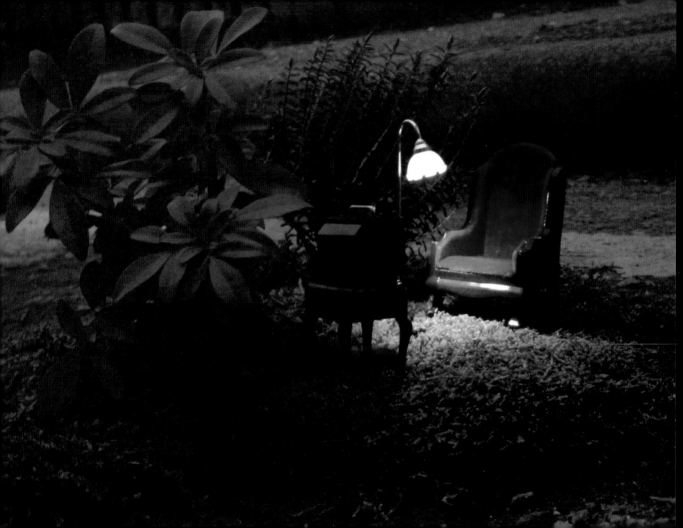

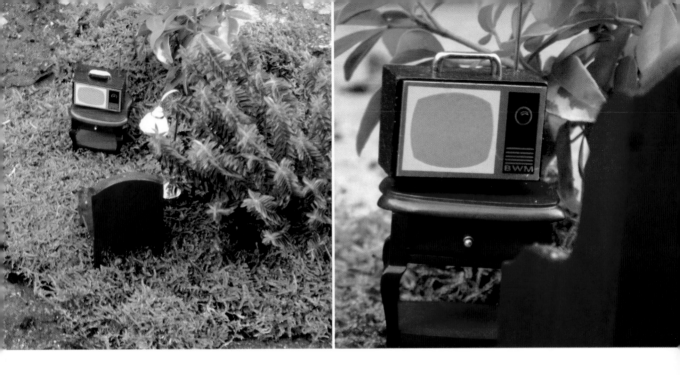

Night Garden

In Jack The Ripper's territory, this garden will help light your way home in Whitechapel's back alleys.

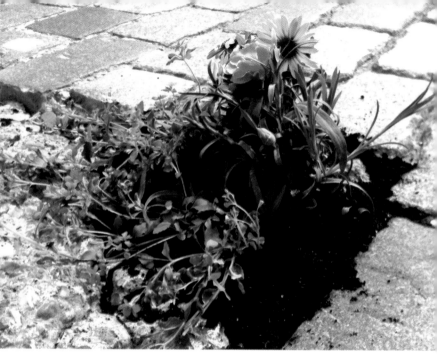

Canalside

Next to the famous Broadway markets, this garden was spotted by a little kid who asked why I hadn't been to his street yet! His grandma called it greening graffiti.

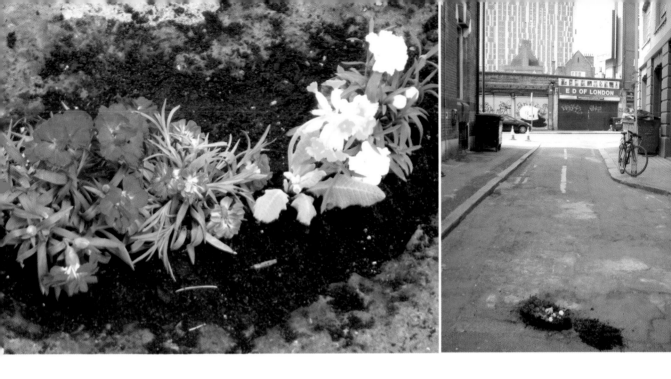

Blaine Lanie

Some tender love and care just off Commercial Road.
The spring bloom lasted a good few weeks until a
nightclub opened next door.

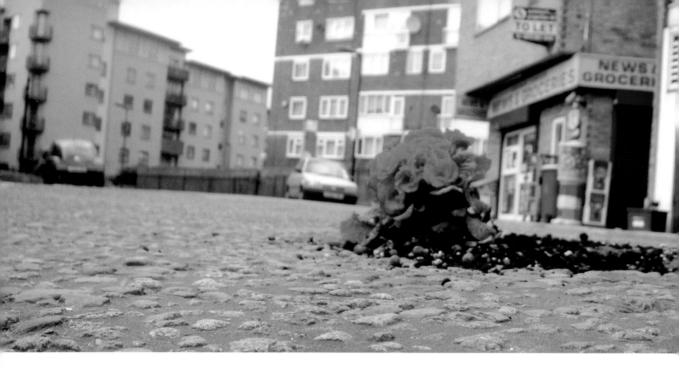

Pinkie Winkie

Just off Bethnal Green Road a splash of pink highlights this little menace to drivers and cyclists.

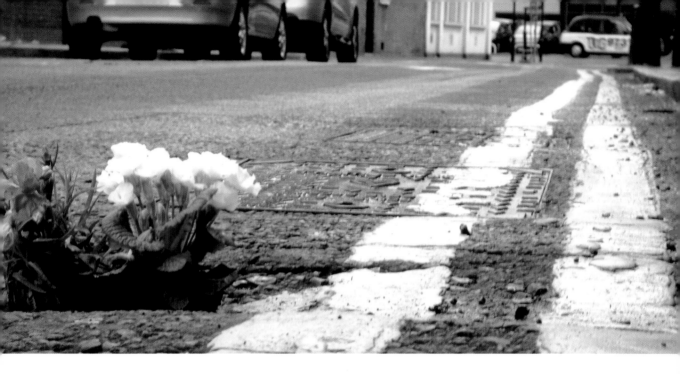

Around the Corner

One of my first gardens. A reason I decided to continue with my gardens is that a guy walked out of his flat hurrying to work; but he stopped, smiled and took a picture.

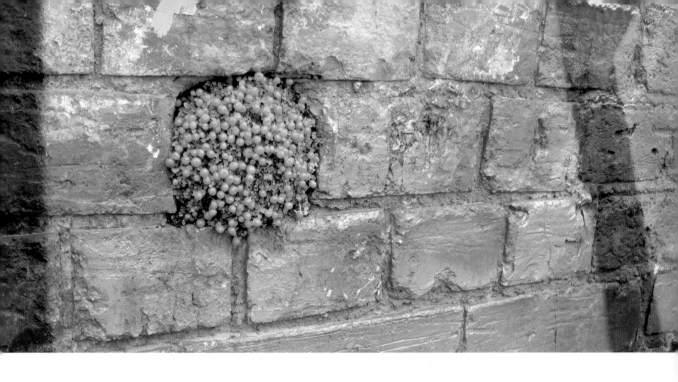

Very Berry

A wall garden, with berries next to this big piece of graffiti.
It lasted a couple of months.

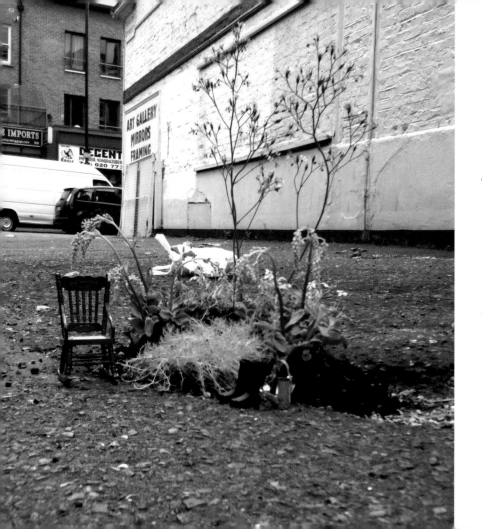

Take a Load Off

Around the corner from Hackney City Farm, here's some respite for the hard working staff.

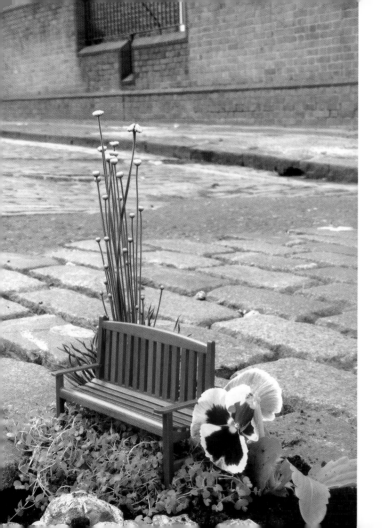

A Sit Down

Have a rest and enjoy the sunshine!
Slow down. Read a book and love life.

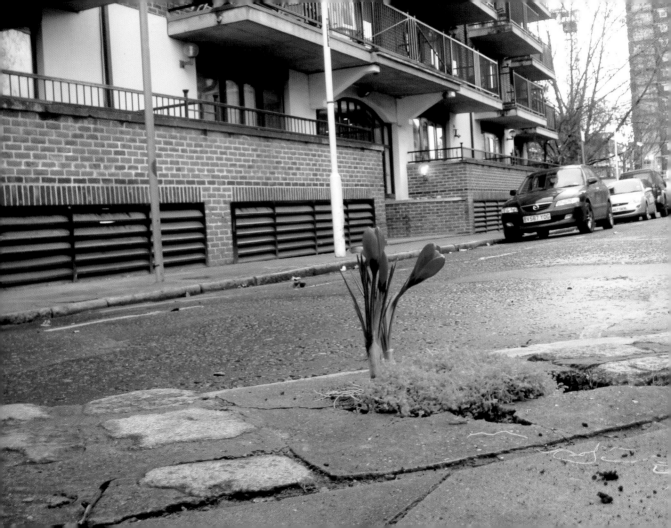

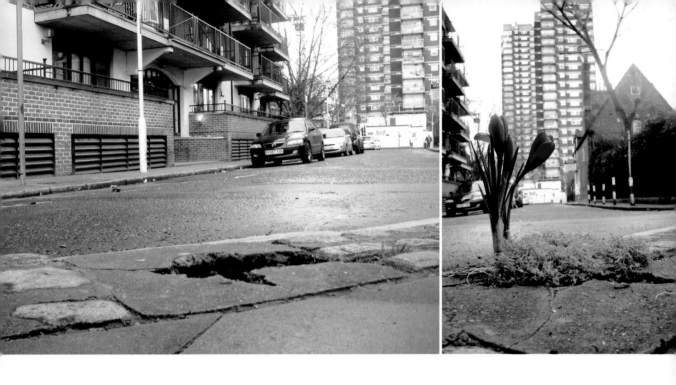

Purple

These lone purple flowers in the urban jungle is one of my favourites. They looked so fragile in the shadow of the big estates. The garden lasted a couple of weeks.

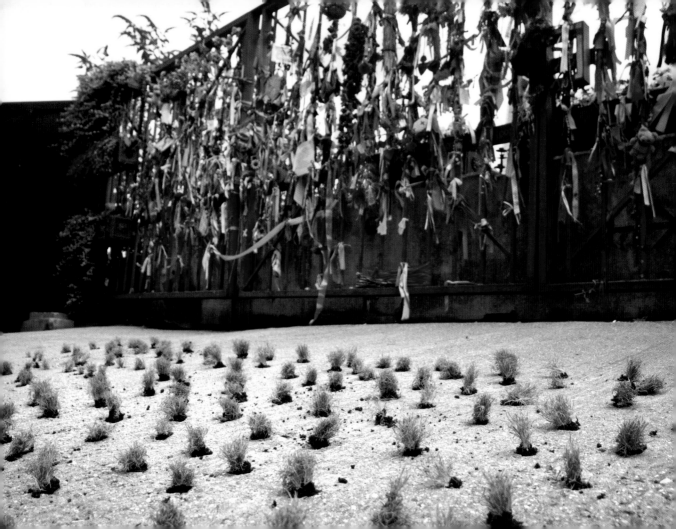

Cross Bones

This little known memorial near London Bridge remembers up to 15,000 paupers and prostitutes buried here over 150 years ago.

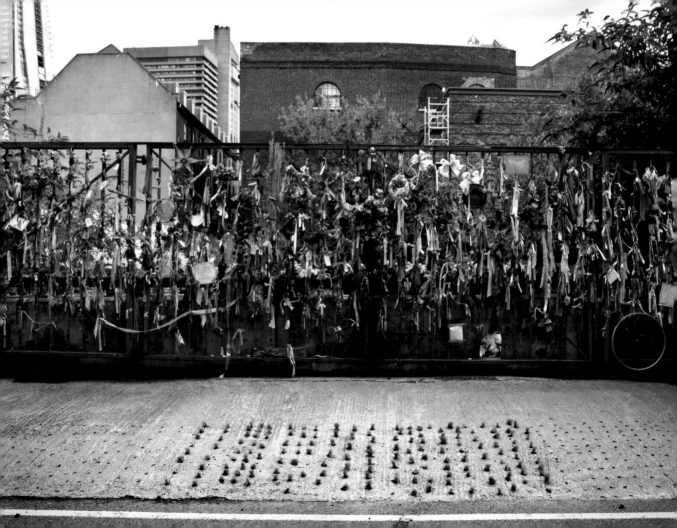

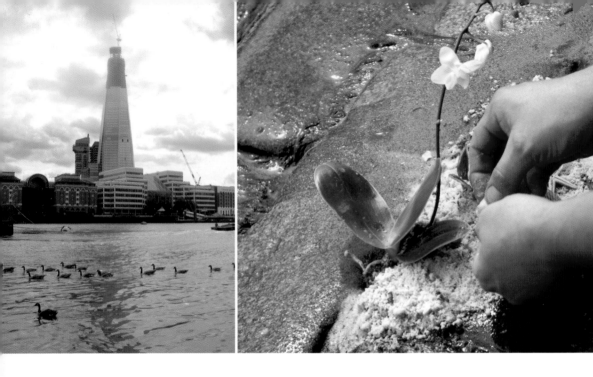

Water Garden

In the shadow of The Shard, a little garden battled with the tide, and lost.

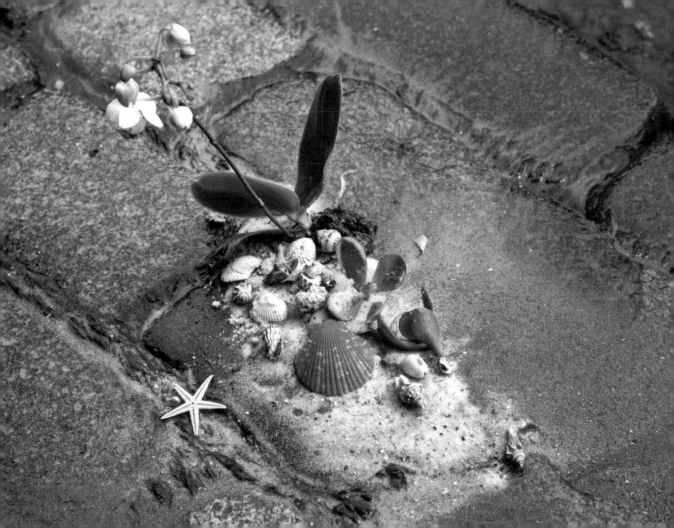

An Eye for an Eye

Gardening outside the Ministry Of Defence, London, was always going to attract a crowd, especially when the aim was to create a miniature London Eye replacing the pods with pots. The crowd included a policeman whose reaction was one of delight and admiration. He left heading out to do some gardening himself.

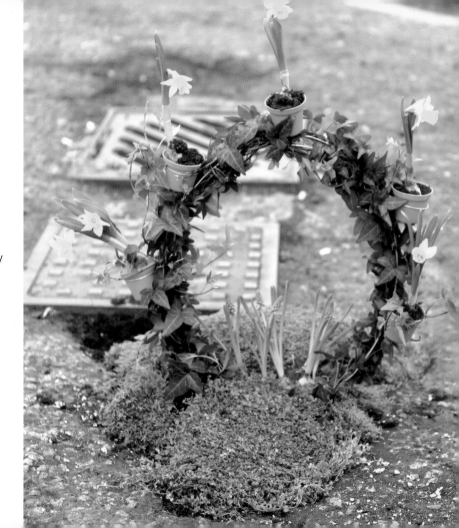

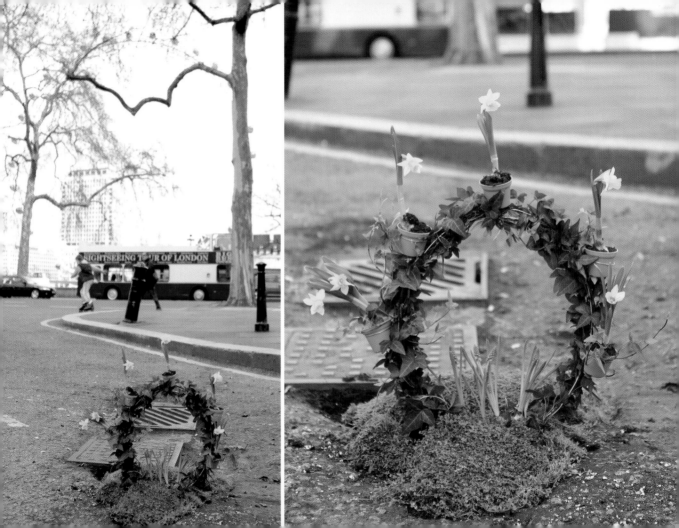

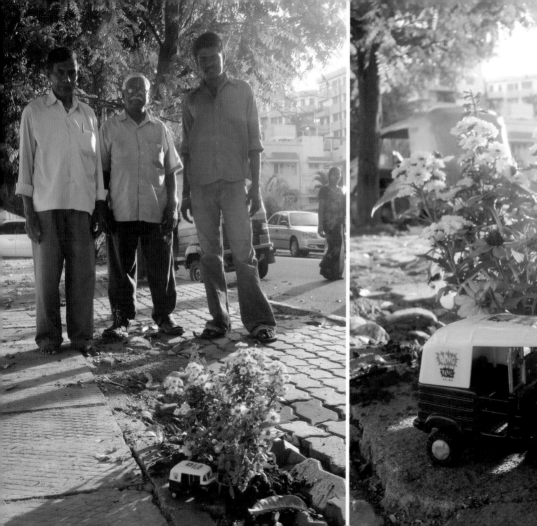
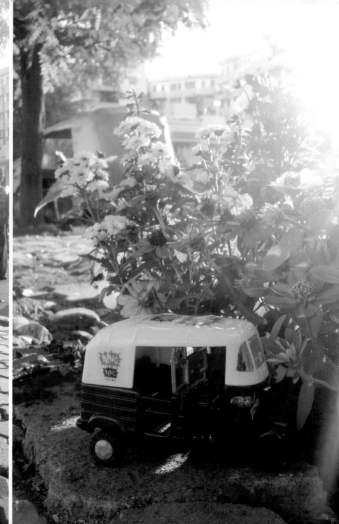

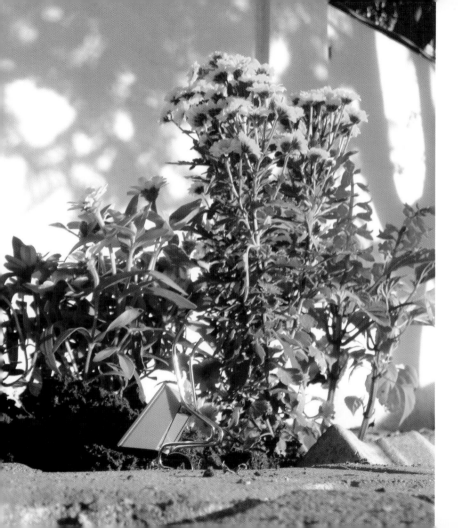

Bangalore, India

The first pothole garden I created outside of the UK was met with confusion and a lot of smiles. The locals in Crescent Street, Bangalore, have a lovely new garden. There's no shortage of pothole gardening sites in that city!

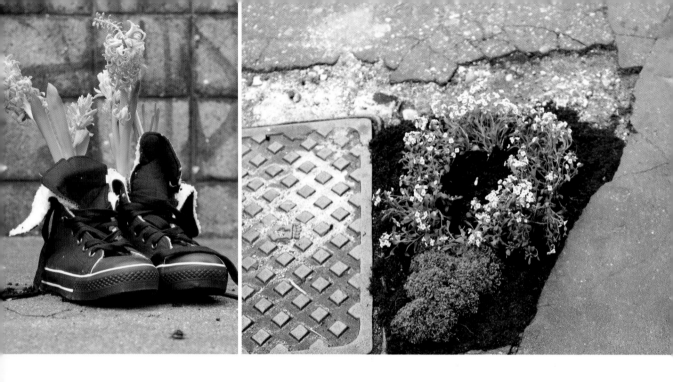

Milano, Italy

Gardening in Milano for Design Week was quite an experience. The series of gardens celebrated Italian culture.

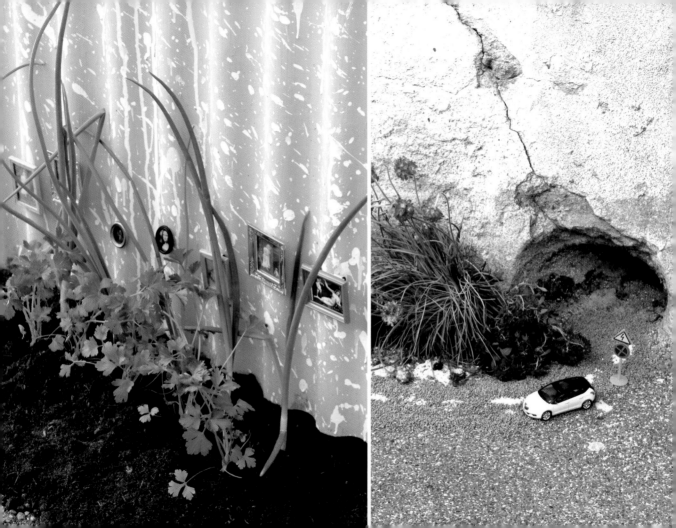

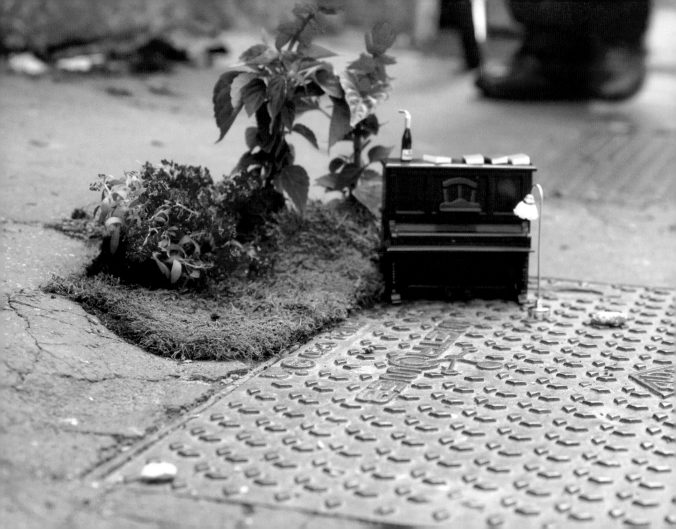

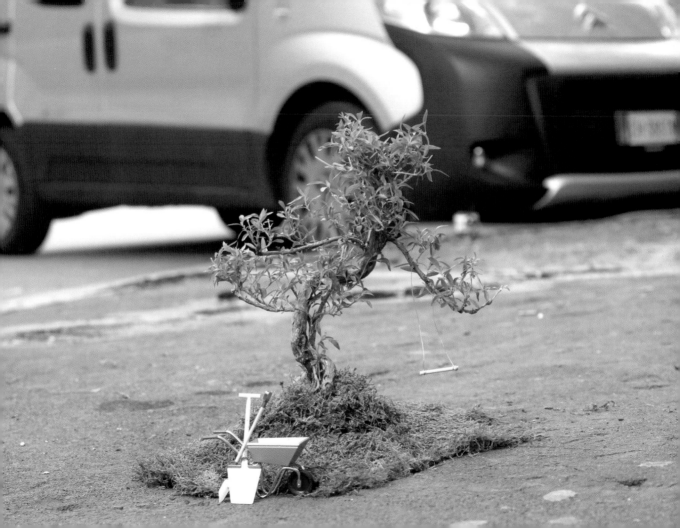